T0198887

To order additional copies of this book, contact:
Xlibris
844-714-8691
www.Xlibris.com
Orders@Xlibris.com

ISBN: 978-1-4134-2991-6 (sc)
ISBN: 978-1-4134-4149-9 (hc)
ISBN: 978-1-4771-8133-1 (e)

Print information available on the last page

Rev. date: 10/28/2020

God's Little Bush!

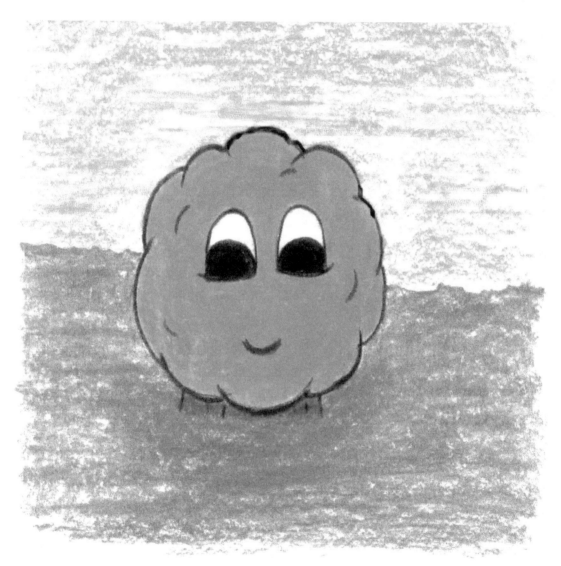

Written by Jeannie Bergland
Illustrated by Cristy Peters

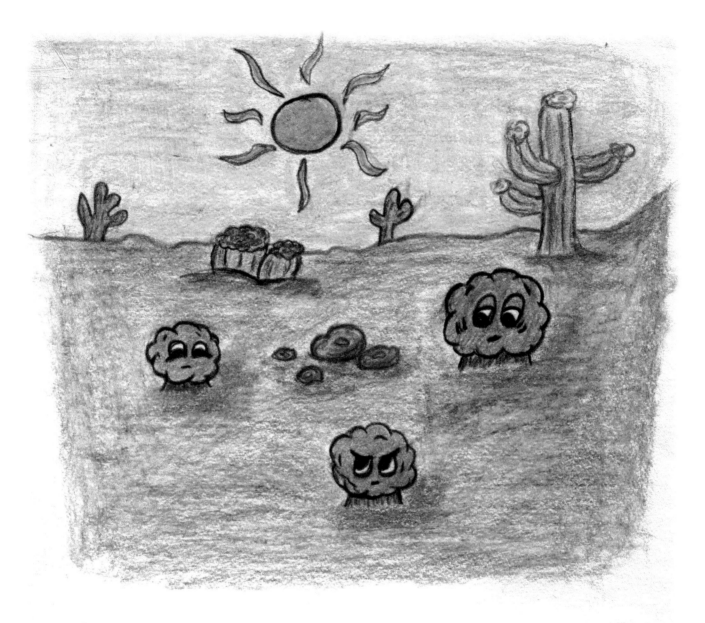

Thousands of years ago,
way out on the backside
of a very hot and dry
desert, some bushes grew.

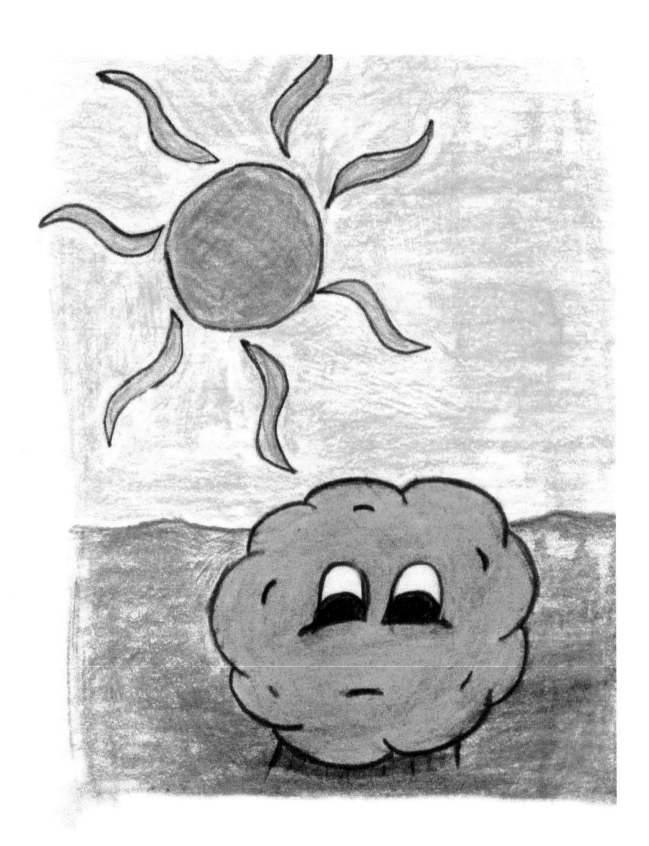

The smallest, youngest bush,
began to complain,
"Why must I be here?
It is so hot and so boring.
Nothing very exciting ever
happens around here."

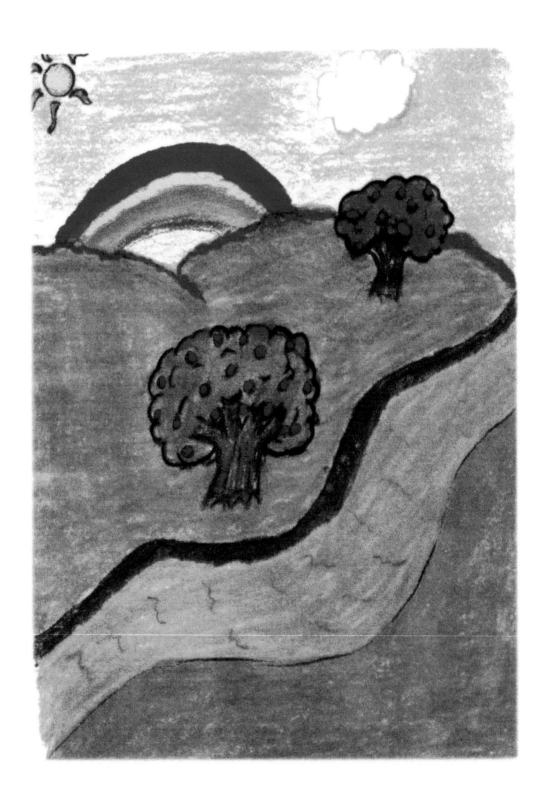

The little bush continued,
"Why can't I be like the tall,
luscious fruit trees, that
grow down in the nice valleys?
Why must I be just a small,
worthless little bush?"

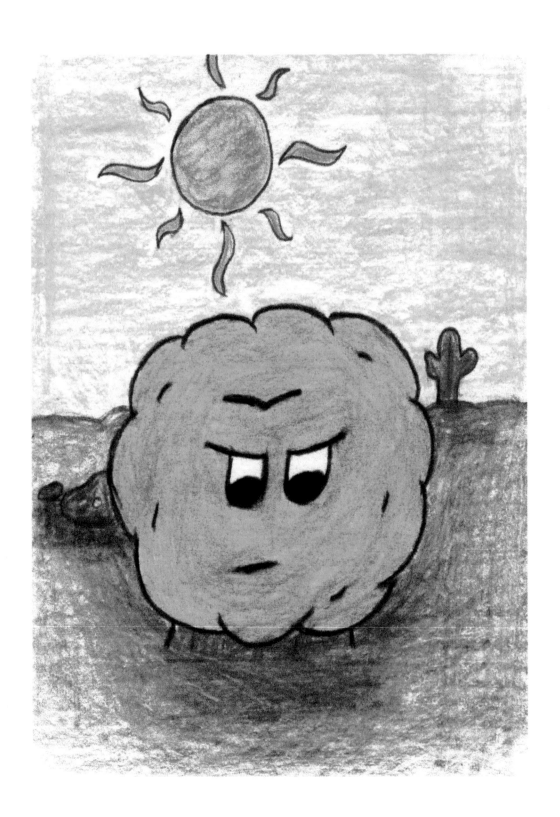

Another bush, that was near by,
had grown very angry, by all
of the complaining and responded,
"Be quiet ! It is bad enough that
we're all frying out here, but you
make things worse by all your
complaining! We don't need a reason for living
here. We just do the best we can to
survive and then we die.
So quit grumbling! "

Just then, an old wise bush,

that had been listening

to them, responded,

in wisdom and in love,

"Is that what you really think life

is all about - just

surviving? Little bush, do you

really see

no reason for living here?"

About that time, another bush,
quickly jumped in and said,
"Of course, that's all there is!
What else could there be to life?"

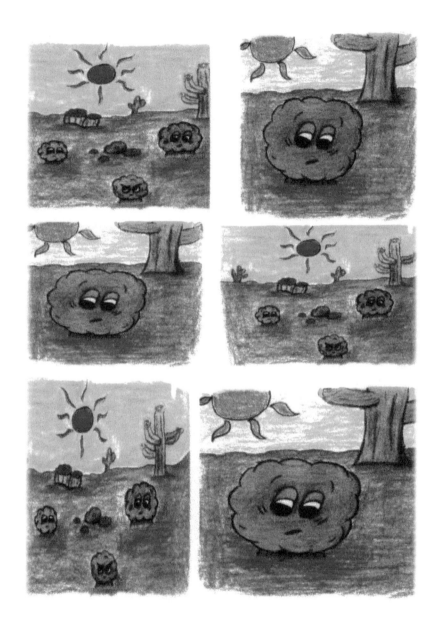

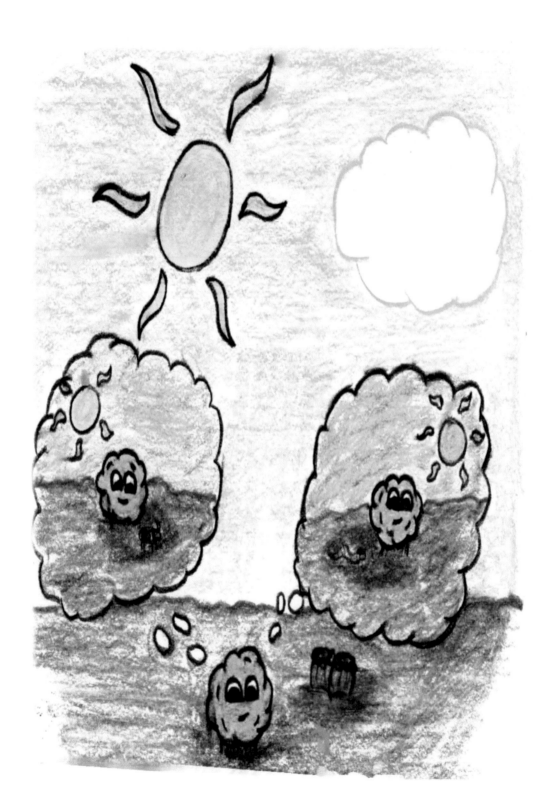

The little bush responded,
"I can speak for myself. "
Then the bush continued,
"I might have a reason for
living here. Maybe to do
something good, like the time
I gave some shade to a bug,
or the time I gave shade to
a snake."

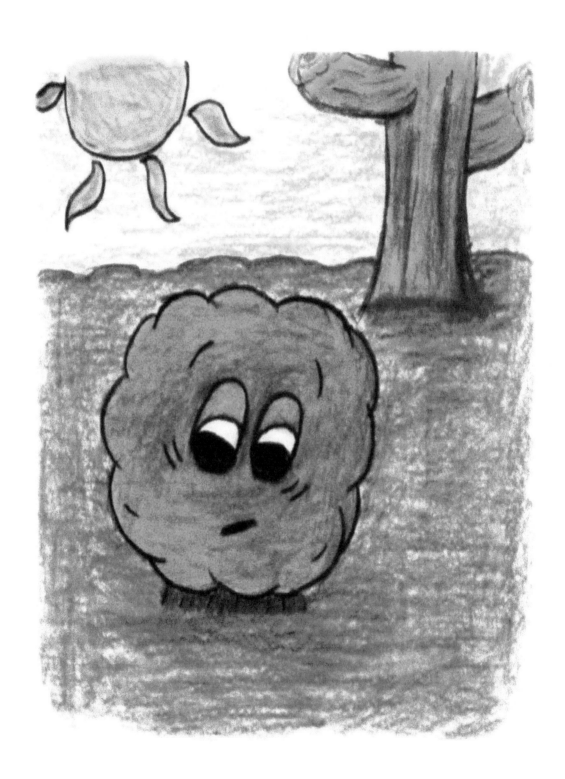

The wise old bush then answered,
"It is always good to do good;
but that's not the main reason we
are here.
You see, the Creator of the Universe
planted us here, and now we have
the honor of growing and living here
for our God.
We are able to thank and praise Him,
for loving us enough to give us life and
the ability to grow, and live here in
this special place.
Not any plant can do that."

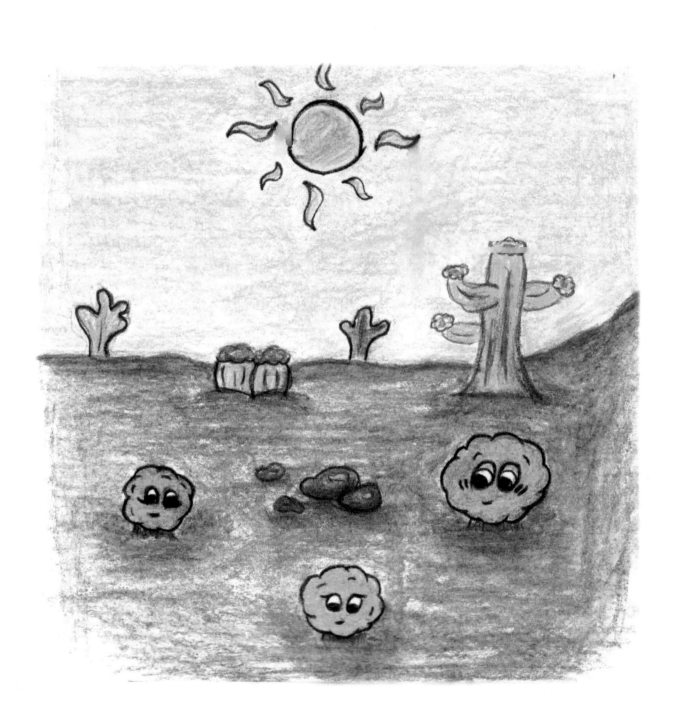

The other bushes were amazed at such
wisdom!
Then the little bush asked,
"Wow! Can we thank and praise God now?"
The wise old bush answered,
"Why, yes! Now would be a great time
to praise Him!"

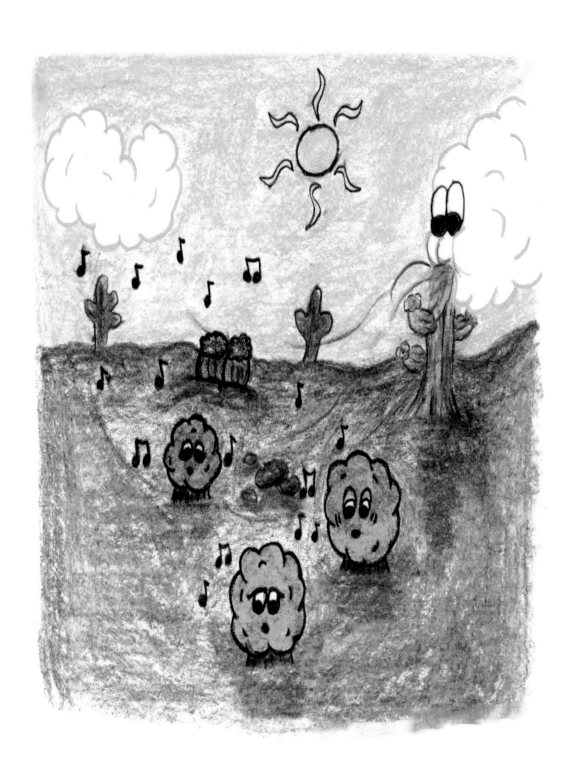

Soon they all began to thank and sing
praises unto God!
As they did, a gentle cool breeze
began to blow, and it picked up their
praises and carried them all the way
up to heaven, all the way up to God!
Now when God heard this joyful sound,
He looked down from heaven, and said,
"Now there is something I can use.
I will use that little bush down there."

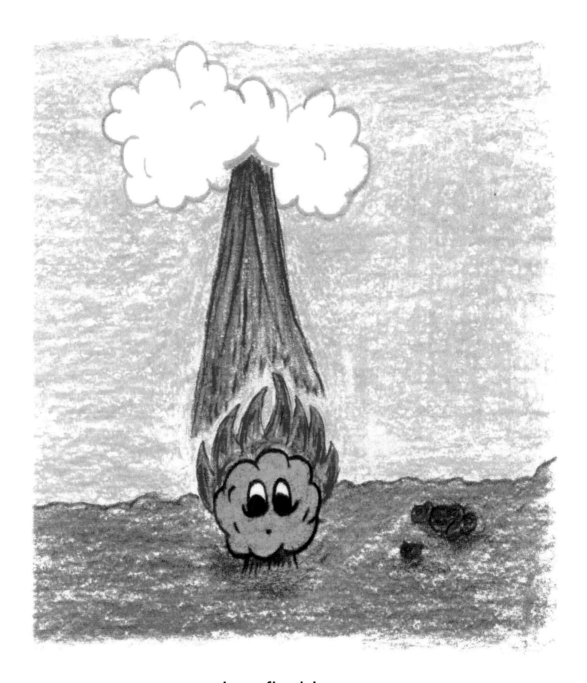

In a flash!
The little bush was set on fire,
by the glory of God, but it wasn't
destroyed!

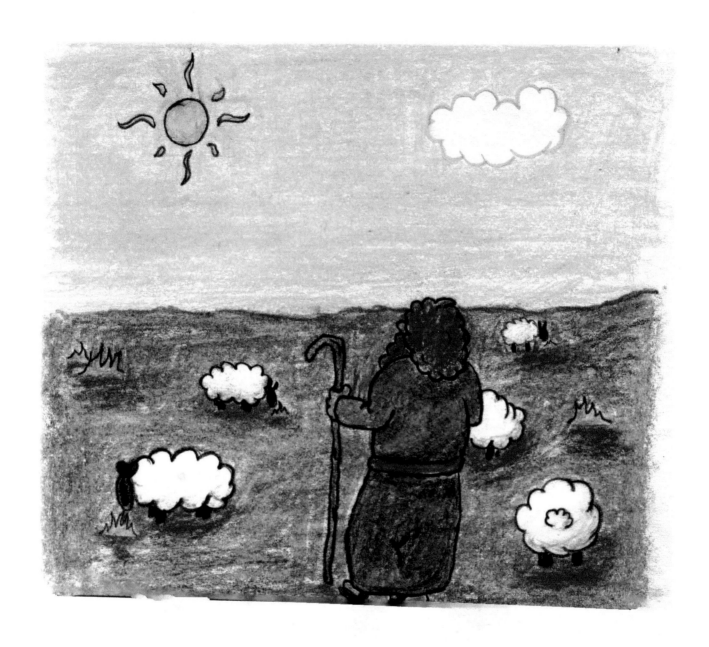

About that time, a shepherd came
passing by and saw the bush on fire;
but it wasn't burned up!
So he went to take a closer look.

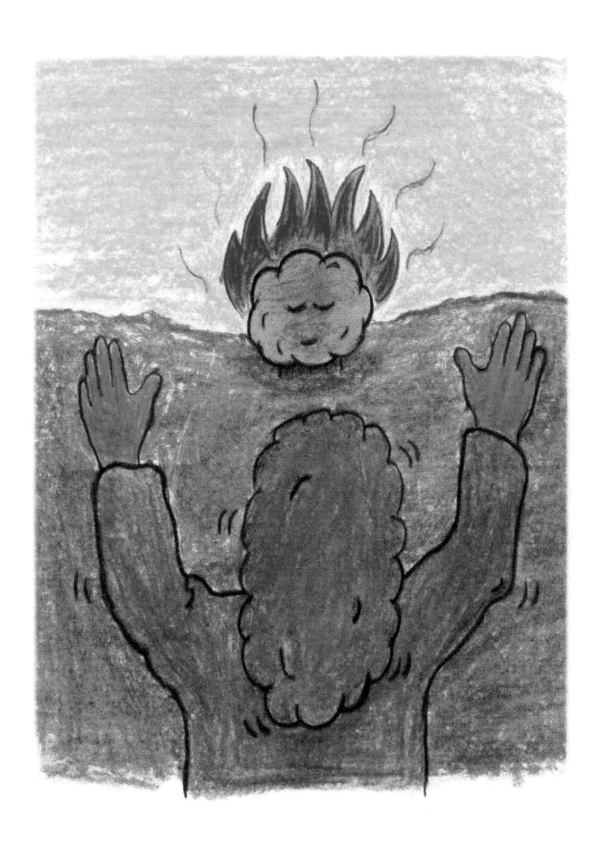

God spoke to the man from the burning bush,
and told him to go speak to a king!
The shepherd did not want to do this, so
he made many excuses on why he could not
do such a thing.
One reason he gave, was because he
could not speak very well.
The little bush was amazed at this!
The bush thought,
"Does this man see that I don't
even have a mouth, and yet,
God is speaking through me?"

The Shepherd finally did obey God.
We know him today as Moses.
You can find this story in the Bible ,
in Exodus 3 & 4.
It may not have happened exactly like this;
but it did happen.
You know God can use you too,
no matter how small you are or where
you live.

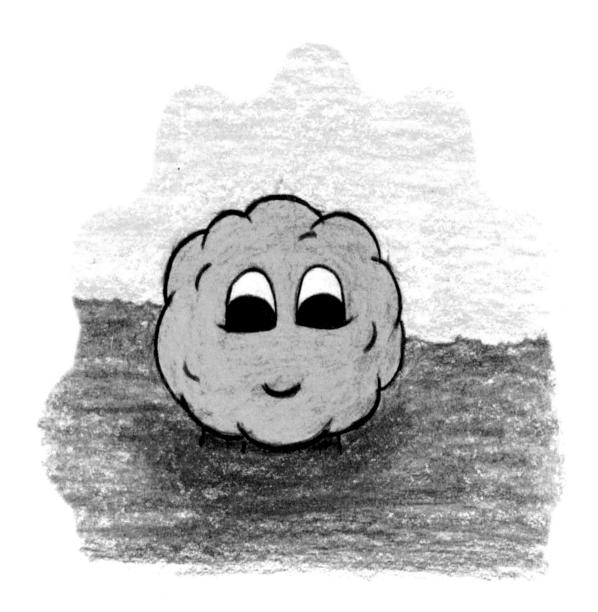

The End!

It is true. God can use anyone.

Have you ever put your faith and trust in Him?

You can do that by asking His Son, Jesus Christ, into your heart.

Here's how:

1. Ask Jesus to come into your heart.
2. Ask Him to forgive you of all the things you've done wrong.
3. Thank Him for coming into your heart.
4. Ask Him to use you for His honor and glory.

You will be so glad you did.

Printed in the United States
By Bookmasters